ArT RANDOM

KYOTO SHOIN

First published in Japan 1989 by KYOTO SHOIN INTERNATIONAL Co., Ltd.
Sanjo agaru, Horikawa, Nakagyo-ku, Kyoto, Japan. TEL[075]841-9123

Editorial director : Kyoichi Tsuzuki
Art director : Ichiro Miyagawa

© Copyright 1989 : Gilles Aillaud
Text copyright 1989 : Hector Obalk

All works are reproduced by courtesy of Atelier Franck Bordas Gallery.

ISBN4-7636-8501-5 C0371 P1980E

Printed and bound in Kyoto by SHASHIN KAGAKU Co., Ltd.

Photo : Jean-Noël Giroix

Translation : Fia, Inc.

cover : Okapi, 1988

Gilles Aillaud

Complete Lithographic Work
1978-1989

Written by Hector Obalk

For a long time, Gilles Aillaud's painting depicted the animals who live in zoos and of whom it is difficult to say whether they are sad or whether they couldn't care less.

The pictorial subject is, on the one hand, too subtle and ambiguous (the sadness, tinged with indifference, of animals in cages) for it to be possible to see there "the penitentiary metaphor of the human condition", as an excessively *ideological* vision of art alleged in the 70s.

ジル・アイヨーの作品の題材に長いあいだなってきたのは動物園の住人、悲しいのだろうかとか、どうでもいいと思っているのだろうかとか、そういうことの判断に苦しむ動物たちであった。

いっぽうでは絵画の主体があまりにも微妙かつ曖昧であるため（檻の中の動物たちの無関心さの入り混じった悲しみ）、70年代に盛んに言われた芸術の過度にイデオロギー的な見方としての、「人

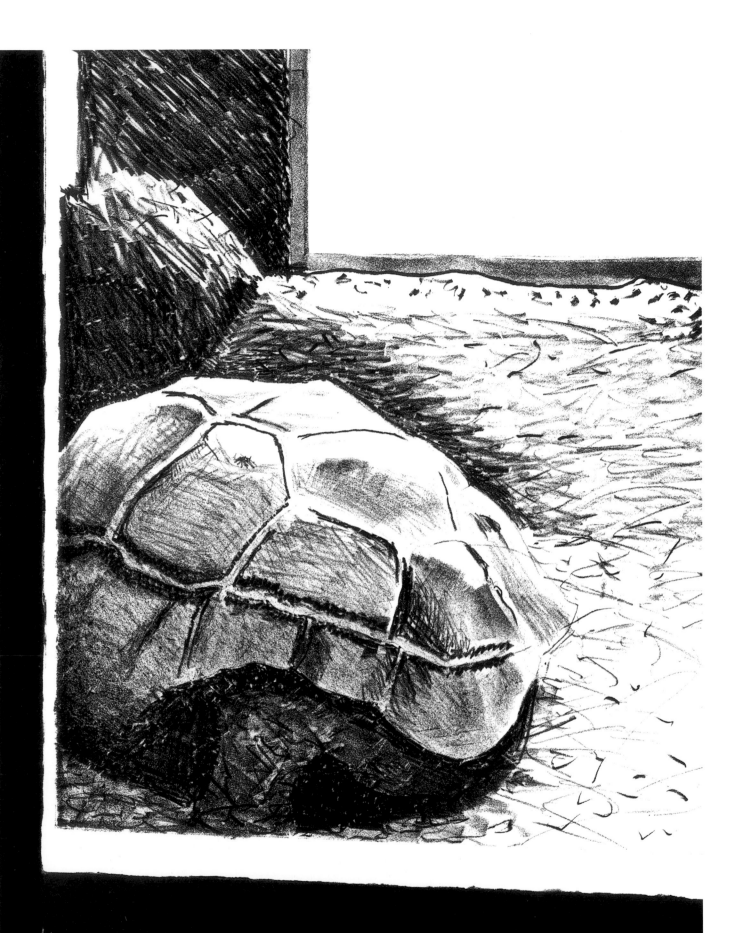

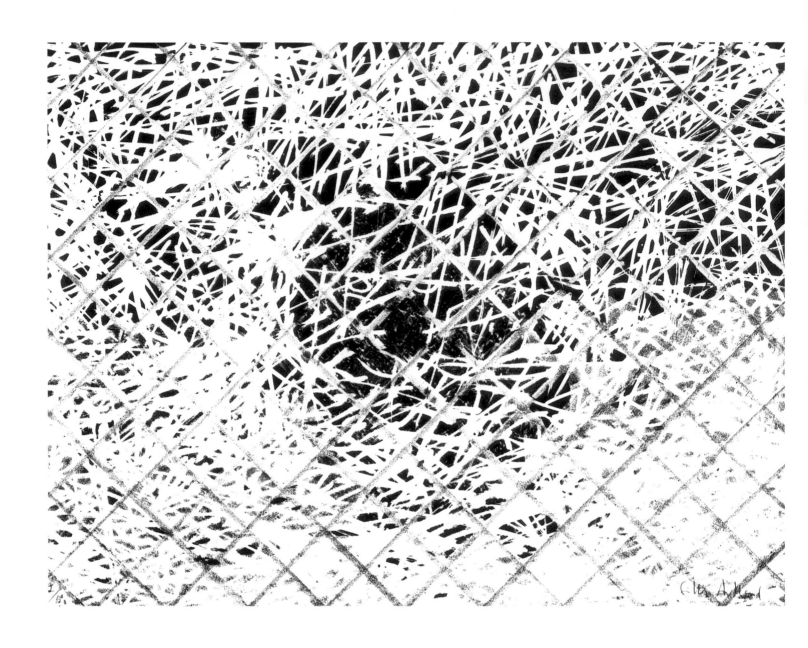

But the subject is , on the other hand, insufficiently monotonous and commonplace (in view of the variety of animal species and the spiritual power of each) for it to be possible for this patiently tenacious depiction of animals to reveal "the ultimate nihilism of the figurative painter who always paints the same thing", as an excessively *intellectual* vision of art alleged, also in the 70s.

間の条件における悔恨の暗喩」をそこに見ることはできない。

　しかしもう一方では、その主体が単調かつ平凡であるとはいえ、（動物の多様性とスピリチュアル・パワーという点から）これも70年代に言われていた芸術の過度に知的な見方としての「常に同じ物を描く具象画家の究極的ニヒリズム」を顕在化させるには、このように辛抱強く動物を描きつづけることでは不充分なのである。

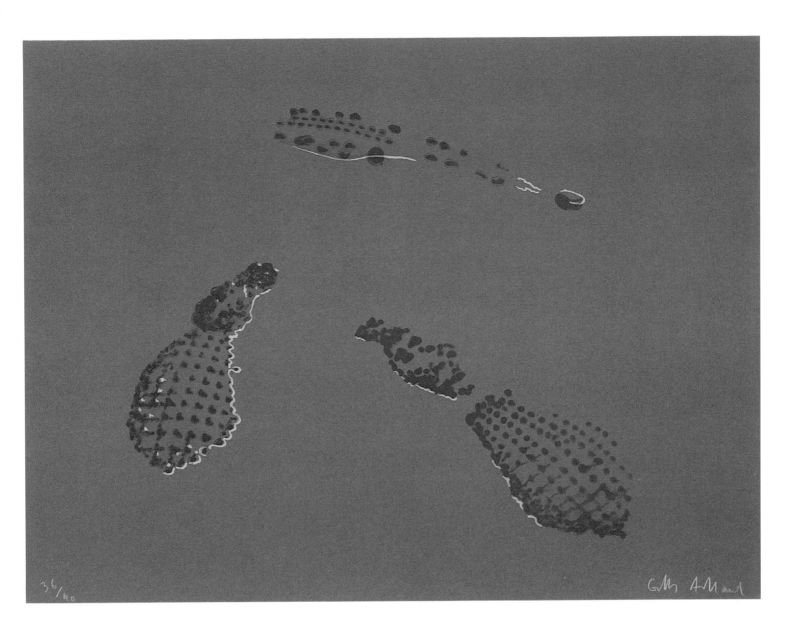

36/40 G. A. Mard

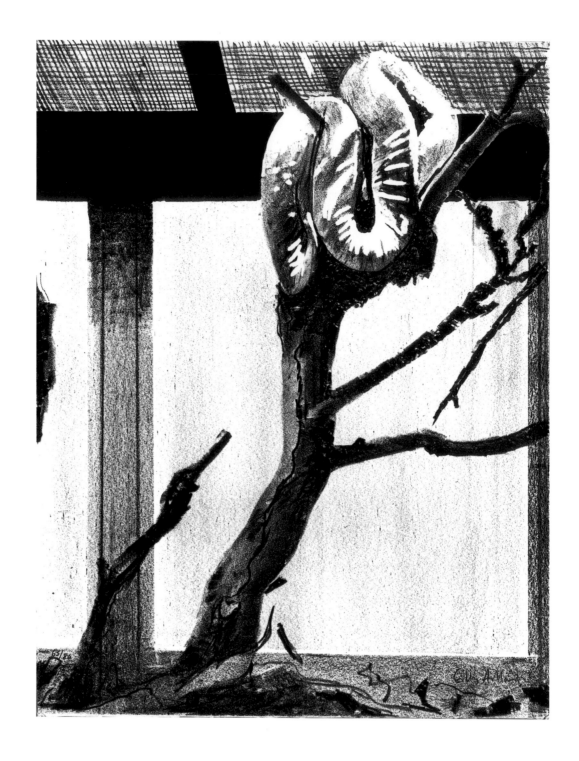

Since then, Gilles Aillaud has painted a number of Greek landscapes, a series of low tides on the Brittany coast, deserts in the Nile valley and some scenes from plays, the rehearsals of which he attended; nothing fundamental to his painting has changed.

There is something inadmissable for exegetes of Gilles Aillaud in the fact that his work has nothing to say about society or art history since its sole concern is to

以来ジル・アイヨーは数多くのギリシャの風景、ブリタニアの海岸に押し寄せる波のシリーズ、ナイル砂漠、演劇の場面や彼自身が参加したリハーサルを絵にしてきた。しかし作品の根底にあるものはなにひとつとして変化していない。

ジル・アイヨーの注釈家にとっては、作品が社会や美術史についてなにも語っていないという点に許し難いものがあるが、これ

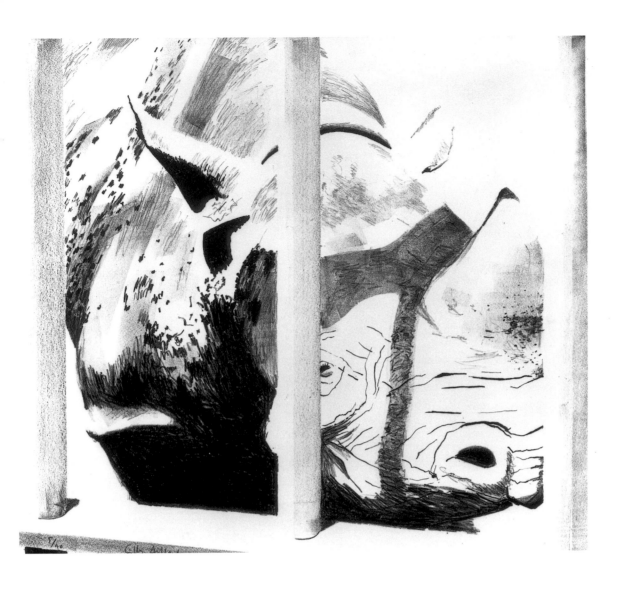

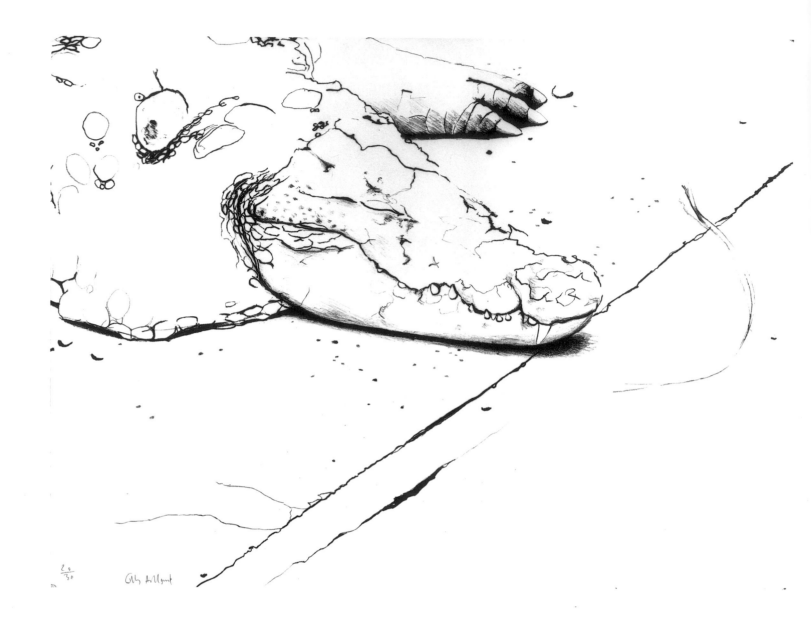

remain as close as possible to what it makes visible and since its only metaphysical interest resides in the naked obviousness of its subject matter.

 In other words, this painting has remained simpler and stronger than the arguments of those who thought they were defending it. As close as ever to what it depicts, as sober as always in the way it depicts it - so much so that it brings tears to one's eyes.

は作品の唯一の目的が目に見えるものから可能な限り離れずにい
ようとすること、そして作品の象徴的意味が唯一その主題のあら
わな明白さにあることに、その理由がある。

　言葉を変えれば作品は、それを守っていたと思っていた者たち
の議論よりも単純かつ力強いものでありつづけたのだ。描く対象
に限りなく近寄り、その描法が常に冷静であるがために、作品を

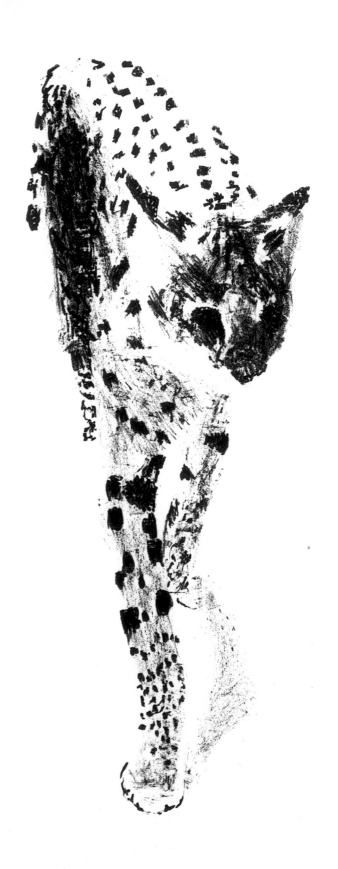

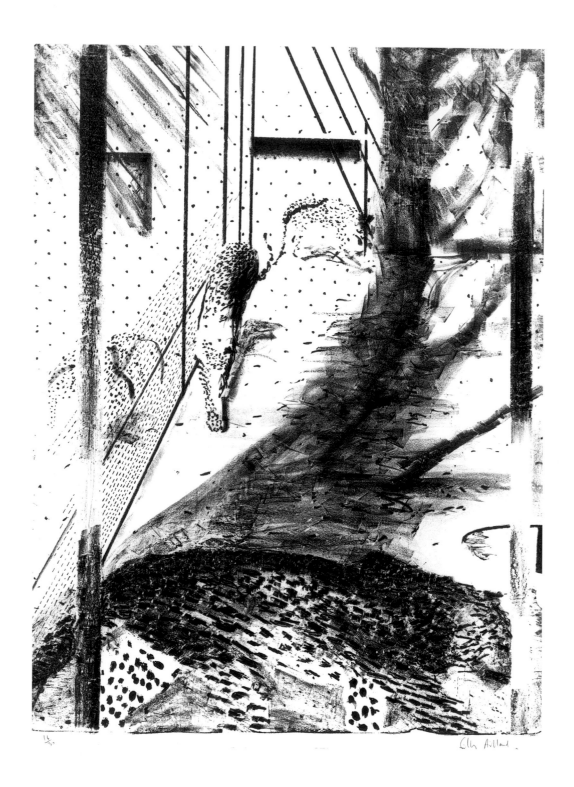

To paint truth to such a degree also means that one is not scared to paint its clichés; a flock of seagulls over a village, a slightly pitiful animal, the horizon at low tide.....

In Gille Aillaud's work, as in the work of François Boisrond (the comparison between the two artist goes no further but it does take the trouble to go that far), if the most threadbare subjects recover something of their

目にするものに涙を誘うのである。

これほどまでにありのままを描くことはまた、その陳腐さを絵にすることをなんら恐れていないということでもある。村の空を舞うカモメの群れ、少しばかりあわれな動物、干潮の水平線など…。ジル・アイヨーの作品では、フランソワ・ボワロンの作品のように（両者の比較は、ある程度まで試みるのもやっかいなこと

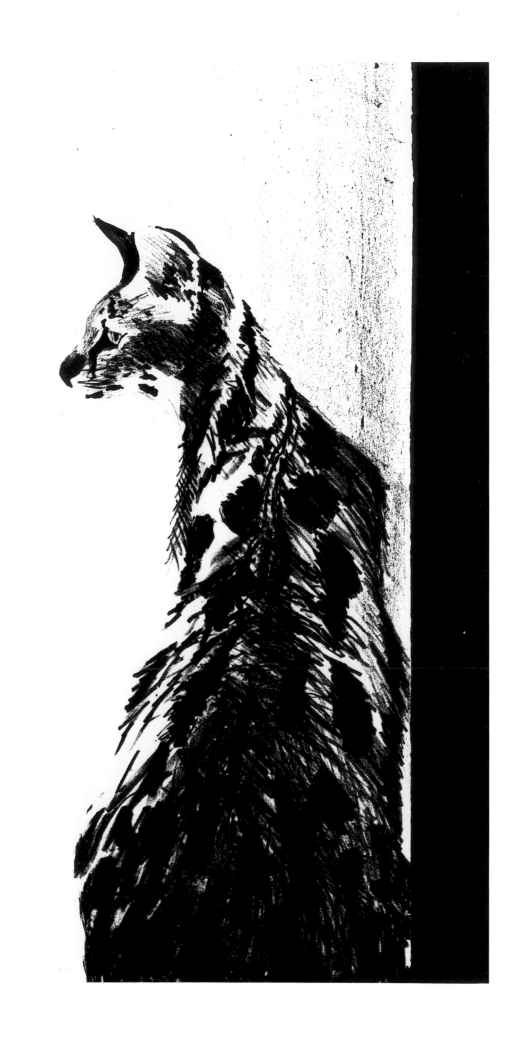

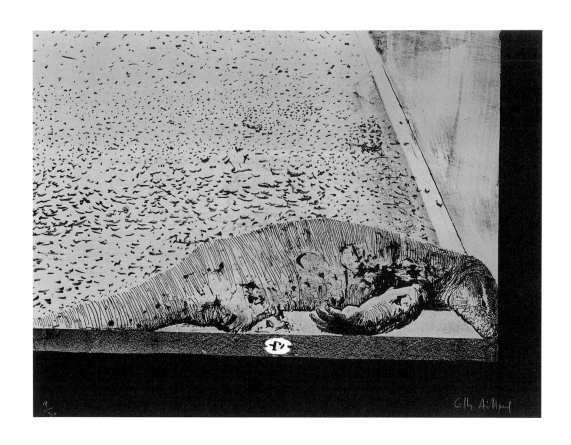

original beauty, in my view it is for the same reasons.

First of all because the subjects have been precisely perceived or intensely experienced by the artist - the animal is not just any old animal, it is a lamentin, a variety of whale, the landscape is not some random spot, it is at Argenton, opposite Ouessant island, where the painter spent the season .

Next, because, unlike almost all Pop Art, Narrative

だが）もし使い古された主題がその本来の美のなにものかを取り戻すとすれば、それは同じ理由からだと私は思う。

第一の理由は主題がアーティストによって正確に認識され、強烈な体験を経たものであることだ——動物は単なる平凡な動物でなくラメンティンと呼ばれる種類のクジラであり、風景は無造作に選んだ場所でなくウェサン島対岸のアルジェントンであり、ここ

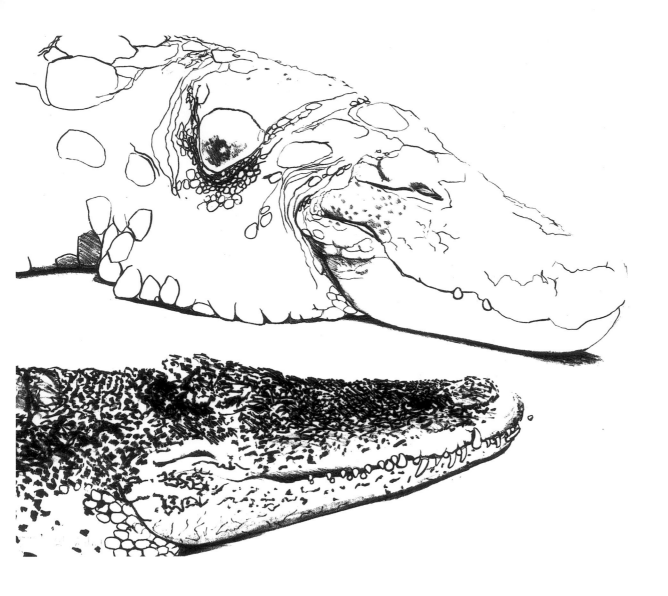

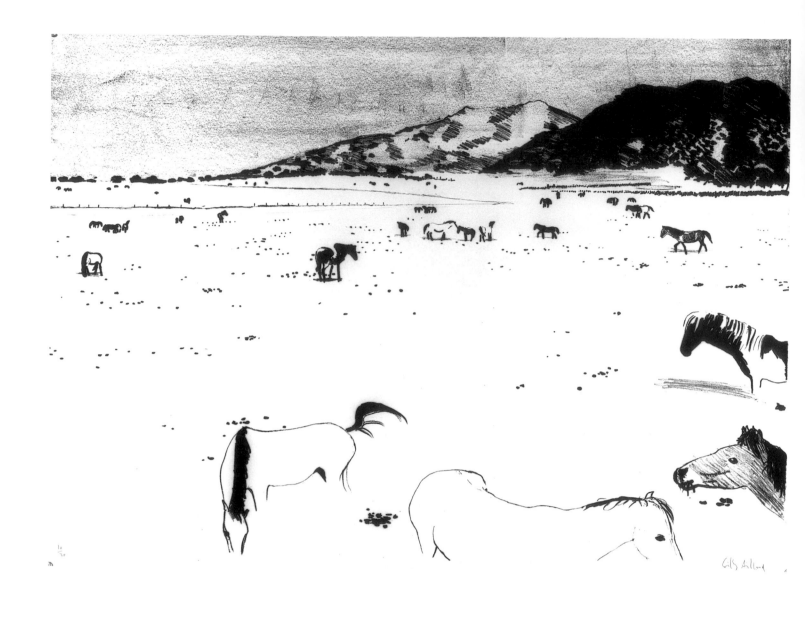

Figuration and Personal Mythology artists, Aillaud has no recourse to chilly distancing, he doesn't use the safety net of quotation or double-indemnity escape clauses of the variety "If it's beautiful, it's true that it's beautiful; if it's ugly, that just shows it's ironical". He doesn't paint an image of the desert by the Nile, he paints the desert by the Nile

Lastly, because although Aillaud manages never to

で画家は数ヶ月を過ごしたのである。

　次にポップアート、叙述的具象、個人的神話派などのアーティストと異なり、アイヨーは対象から距離を置くクールな手法は用いないし、次のような引用という安全網や、特別倍額補償個条の抜け穴を利用したりはしない。「美しく描けたものは美しいのだし、醜く描けたものは、それは皮肉でということなのだ。」彼はナ

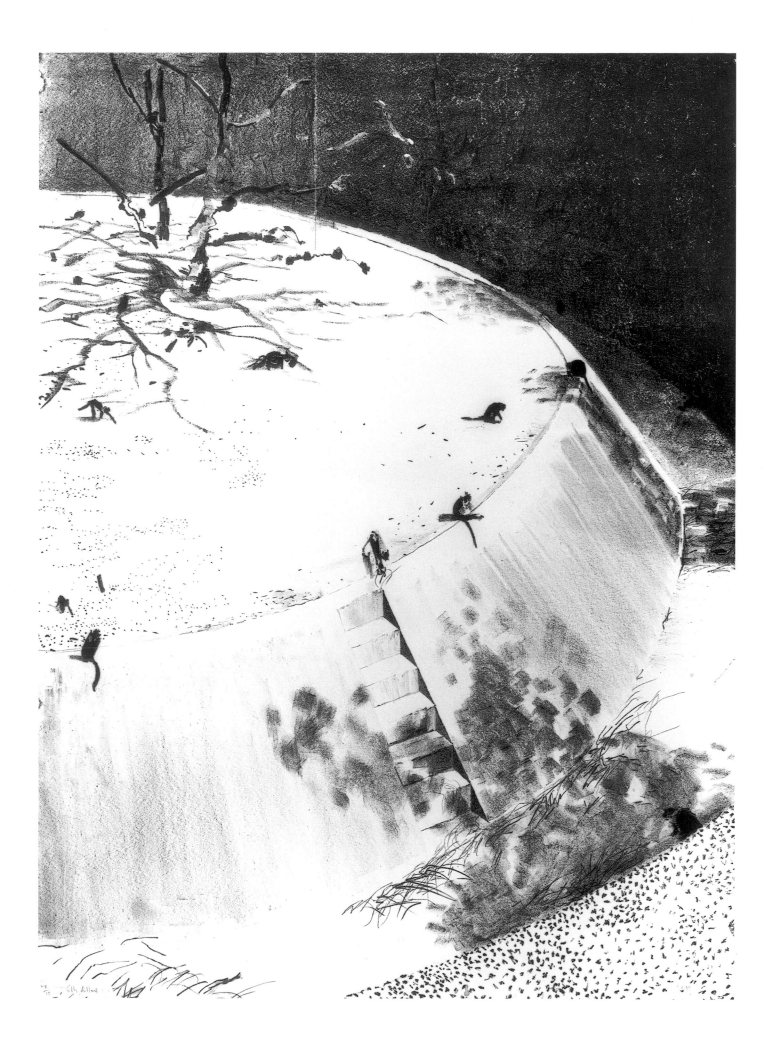

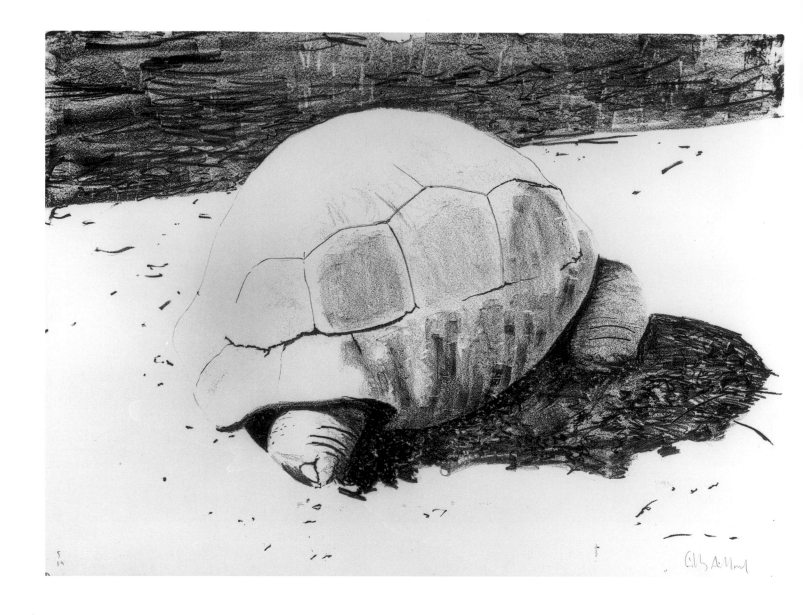

tip over into the conventional, into the weakly lyrical or the unbelievably pathetic, he perpetually runs the risk of doing so, and this is why he is a great artist.

For a while it may be true that a painter's sincerity and his frontal attention to his subject are proof of courage, more often than not they lead to the production of kitsch.

This may be seen from the work of all those, who,

イル川岸の砂漠のイメージを描くのではなく、ナイル川岸の砂漠そのものを描くのだ。

最後に、アイヨーは因習や弱々しい叙情や極端な感傷に踏み込むことのないよう努力しつつ、しかもそうした危険をつねに犯していて、だからこそ彼が優れたアーティストであるといえる。

すなわち、主題に対する画家の誠実さや素直な観察が勇気の証

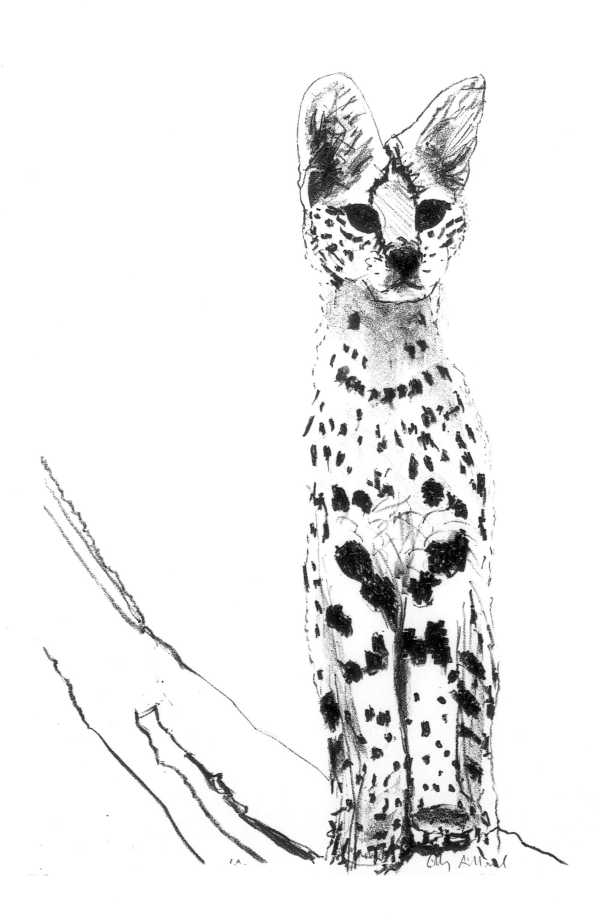

involuntarily, like Chagall, Chia, Blais and others, unfortunately failed into the area where the greatest art is poised a knife-edge away from the ridiculous.

When Marquet painted the Seine as brown as a country pathway (this is the actual color of the Seine at certain hours of the year), he ran the risk of completely missing the desired effect and of people saying things such as "Look, a Surrealist painting. The Seine is dry".

明であるいっぽうで、ときとしてこれらがキッチュを生み出すことになるからである。このことはおそらく、例えばシャガール、キア、ブレや他の、もっとも優れた作品と滑稽とがナイフの刃一枚で隔てられた領域へとあえて踏みこみ、賞賛を得ているアーティストすべての作品からもわかるであろう。

マルケがセーヌ川を田舎道のごとく茶色く描いたとき（これは

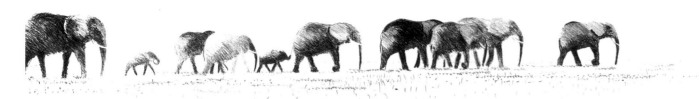

Gilles Aillaud

Born in Paris, on the 5th of June 1928. Lives and works in Paris.
Son of French architect Emile Aillaud. Schooling at *Cours Hattemer* and at *Lycée Condorcet*. Philosophy studies leading to Ecole Normale Supérieure. G.A. starts painting in 1949, and works solitarily during 10 years. Exhibits his works in the *Salon de la Jeune Peinture* (Paris) in 1959. He will become a member of the board of this *Salon* Five years later. In 1961, meets painter Eduardo Arroyo with whom he will often collaborate : Frescos, exhibitions, theater décors, art magazine (Rebelote).

Collective works : *Une passion dans le désert*. 1964 (with Arroyo and Recalcati), 13 panels 130 cm hight, after a Balzac's short story, galerie St German, Paris •*Vivre et laisser mourir ou la fin tragique de Marcel Duchamp*. 1965 (with Arroyo and Recalcati), galerie Creuze, Paris • *atelier populaire*. takes part in the creation of the "may 68 posters" • *Salle rouge pour le Viet Nam*. 1968, ARC, Paris • Magazine *Rebelote* (with P. Buraglio), 1973.

Wall paintings: 6 panels 3m high, 1986, *gare d'Orsay PER* metro station, under *Musée d'Orsay*, Paris • Diptych, 11m high, 1987, in the entry of *Ecole Normale Supérieure des Sciences* of Lyons, France.

Lithographic works: From 1978, G.A. has achieved 20 or so black-and-white original lithographies, executed directly on stone, in Franck Bordas studio, Paris. He has also achieved two volumes of an *Encyclopedia of Animals including Minerals*, with Bordas studio.

Gallery exhibitions: *Niepce*, Paris (1952) • *Claude Levin*, Paris (1963 + catalogue) • *Galerie du Dragon* (1966 + catalogue) • *Galerie Il fante di Spade*, Rome/Milan (1967 + catalogue; 1969; 1972 + catalogue; 1977 + catalogue) • *galleria de Foscherari*, Bologne (1968 + catalogue) • *Galleria dei Lanzi*, Milan (1972) • *Galleria del teatro*, Parme (1972 + catalogue) • *Claude Bernard*, Paris (1974 + catalogue) • *Karl Flinker*, Paris (1978 + catalogue; 1982 + catalogue) • *Galerie Atmosphères*, Bruxelles (1981) • *Barbara Gladstone*, New York (1982) • *Galerie du 7 / Atelier Franck Bordas* (1983 + revue lithographique; 1988 + livre lithographique) • *Galerie de France*, Paris (1987 + catalogue; 1988) • *Galerie agnès b.*, Paris (1987)

Museum exhibitions: *A.R.C. Musée d'art Moderne de la Ville de Paris* (1971 + catalogue; 1980 + catalogue) • *Società promotrice Belle Arti*, Turin, Italy (1971 + catalogue) • *Maison de la Culture de St-Etienne*, France (1981 + catalogue) • *Hotel d'Escoville*, Caen, France (1982), *I.C.A.*, London (1982 + catalogue) • *Galerie de l'Hotel de Ville de Villeurbanne* (1987 + catalogue)

Theater décors and costumes: *Dans la jungle des villes* (in coll. with Ch. Laurent and P. Cauchelier) by B. Brecht, staged by Vincent Jourdheuil, Avignon and Paris, 1972 • *Les Bacchantes* (in coll. with E, Arroyo) by Euripide, staged by Klaus Michael Grüber, Schaubühne, Berlin, 1974 • *Faust-Salpêtrière* (in coll. with E. Arroyo), after Goethe, staged by K.M. Grüber, Chapelle de la Salpêtrière, Paris, 1975 • *Hamlet-Machine* by Heiner Müller, staged by Jean Jourdheuil, théâtre Gérard Philipe, St-Denis, France, 1979 • *Faust* by Goethe, staged by K.M. Grüber, Freie Volksbuuhne, Berlin, 1982 • *Le rocher, la lande, la librairie*, after Montaigne, stage adaptation by J.Jourdheuil and Jean-François Peyret, théâtre de la Commune, Aubervilliers, France, 1982 • *Hamlet* by Shakespeare, staged by K.Grüber, Schaubühne, Berlin, 1982 • *La tragédie de Coriolan* by Shakespeare (with Titina Maselli), staged by B. Sobel, théâtre de Gennevilliers, France, 1983 • *Heiner Müller - de l'Allemagne*, by J. Jourdheuil and J.F. Peyret, Petit Odéon, Paris, 1983 • *Sur la grand' route* by Tchekhov, staged by K.M. Grüber, Schaubühne, Berlin, 1984 • *Bérénice* by Racine, staged by K.M. Grüber, Comédie française, Paris, 1984 • *Le Roi Lear* by Shakespeare, staged by K.M. Grüber, Schaubühne, Berlin, 1985 • *Bantam* by Eduardo Arroyo (with A. Recalcati), staged by K.M. Grüber, Residenz Theater, Munich, 1986 • *Pionniers à Ingolstadt* by Mariluise Fleisser, staged by Bérangère Bonvoisin, Th. des Amendiers, Nanterre, France, 1987 • *La Medesima Strada*, stage adaptation by G. Aillaud, J.C. Bailly and K.M. Grüber, piccolo teatro de Milano, Italy, 1988.

Monographs: *Gilles Aillaud, le proche et le lointain*. texts by John Berger, Catherine Thieck and Michel Sager, Ed. du Regard, Paris, 1980, 104 pages • *Aillaud par/by Obalk*. galerie de France, 1987, 24 pages • *Gilles Aillaud, dans le vif du sujet*. par J.L. Schefer, Hazan Ed., Paris, 1987, 146 pages.

Aillaud's writings: *Œuvres complètes 1978-80* (porms) bilingual French-German ed., Alpheus Verlag, Berlin • *Cargo no. 2* (livre lithographique + poésie by G.A.), Ed. Atelier Franck Bordas, Paris, 1983 • "Voir sans être vu" (paper about Vermeer) in *Vermeer*, Hazan Ed., 1985 • *Dans le bleu foncé du Matin*. Christian Bourgois Ed., Paris, 1987 • *Vermeer et Spinoza* (theater play) Christian Bourgois Ed., Paris, 1987 • *Ecrits 1965-1983* (collected papers) Editions 127, Valence, France, 1987 • *La medesima strada* (play after the Presocratics, dialogues and commentaries) in coll. with J.C. Bailly and K.M. Grüber, Christian Bourgois Ed., Paris, 1989.

When Aillaud places his animals one behind the other in such a concentrated fashion that the arrangement might damage the usual visibility of the image or when he paints the twisted paw of a big cat in such a way that it might look badly drawn then he is running the same sort of risk. Yet there is nothing wrong with the way the cat has been drawn.

The gesture initiated by the paw is quite simply

実際一年のある時期のセーヌ川の本当の色である)、彼は人々に望まれた効果をまったく裏切って、「見てみろ、シュールレアリストの絵だ。セーヌが乾いている」と言われる危険を犯した。

アイヨーがある動物の背後に次々と別の動物を並べていく非常に緊密なスタイルを取ったがためにイメージが普段のように見えにくくなってしまったとき、あるいは大きな猫の足をねじって描

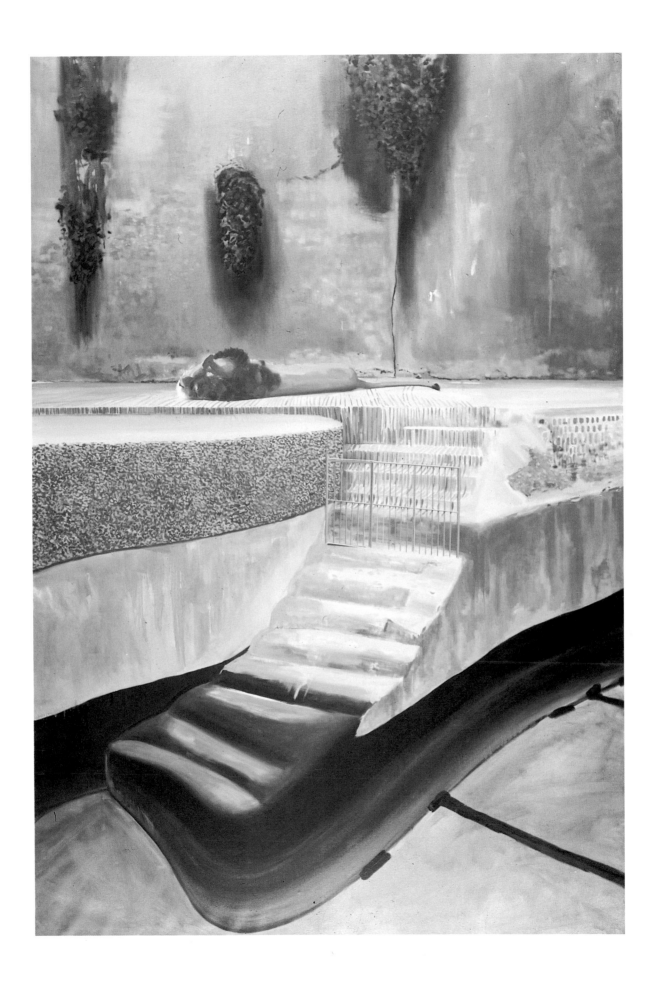

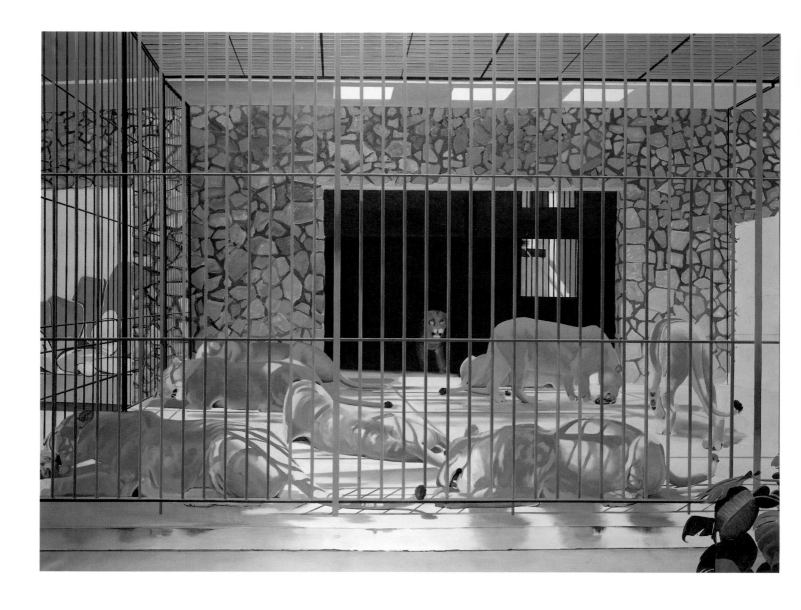

contradicted by a movement of the shoulder. The serval changed its mind, such things happen and that's that: Aillaud paints the thing as it is. As for the disposition of the turtles in their tank or of the kangaroos in their pen, they also obey the same principle of intimate reality.

It is as if the animals had not been arranged by the painter but had taken up a position on the canvas of their own free will, - in a disorderly manner that is alive, real

いて一見下手に見えてしまうとき、アイヨーは同種の危険を犯しているのである。

しかし、猫の描かれかたにはどこも悪いところはない。足のポーズは肩の動きと極めて単純な対照をなしている。サーバル猫が気分を変える、するとこういうことが起こる、ただそれだけなのだ。アイヨーはあるがままに描くのである。

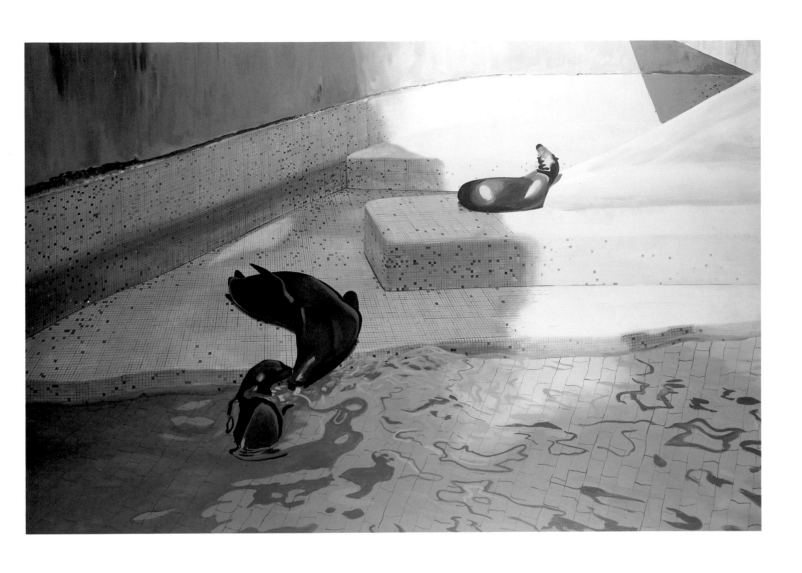

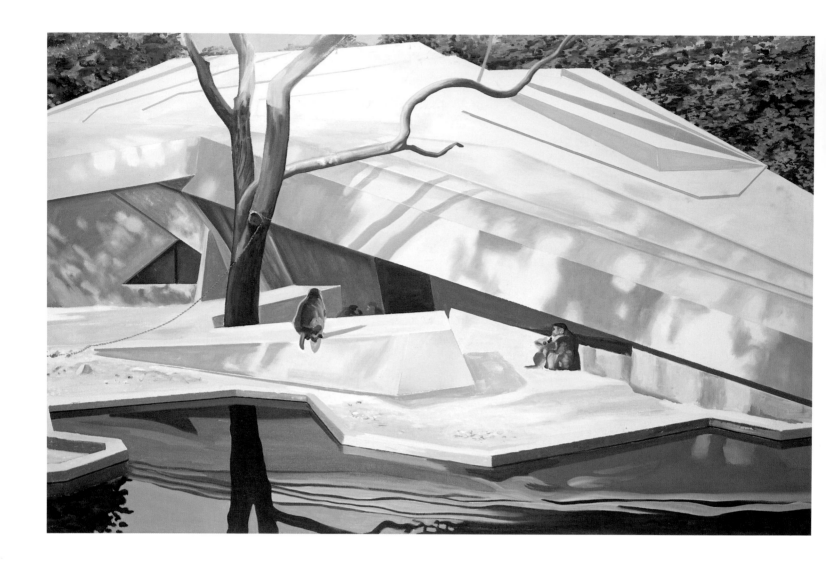

and unpredictable, ensuring that none of that which is asleep under the eyes of the viewer looks composed or congealed.

(This is also how Aillaud's paintings convey the clear impression that the disorder, however tranquil, is about to change form one moment to the next: the dunes are about to change shape, the animal is on the point of shifting position....).

水漕の亀や檻の中のカンガルーの配置にしても、現実に即す同じ原理に従っているまでであり、あたかも画家が動物を配置したのではなく、動物が好き勝手にキャンバスの上に居場所を決めたかのようだ。その配置はいきいきとしてリアルな、気粉れかつ無秩序であり、見る者の眼の下で眠るもののなにひとつとして、意図的に構成されているとか硬直しているといった感じを与えない

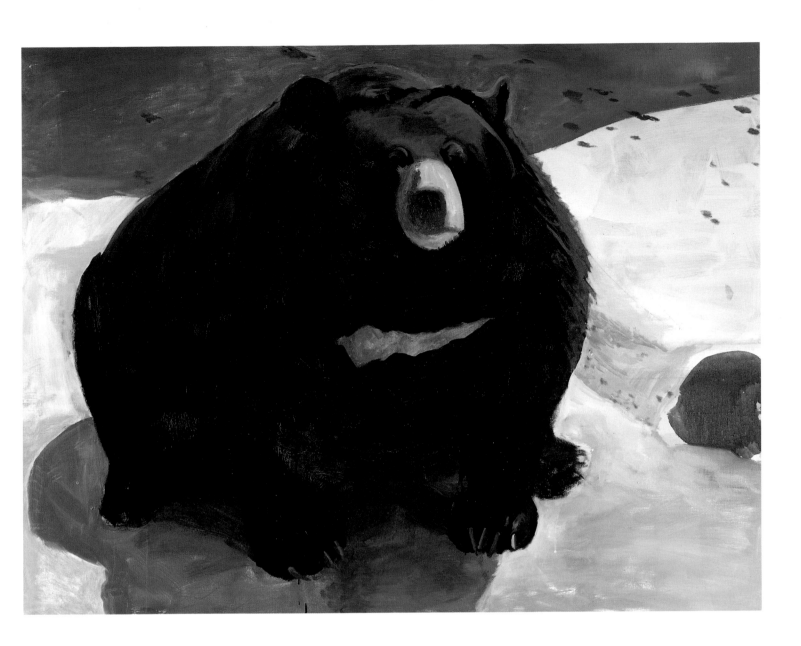

To paint truth involves not only painting its clichés but its deceptive appearances as well.

It is because Aillaud (here unlike Boisrond) does not have a cut and dried manner of "making lions" or of "making the sea" that his painting does not shirk any of the aspects (the most ineffable, the most unforseeable) that reality may adopt at the moment of painting, be-

ようになっている。

（この手法はまたアイヨーの作品の、どんなに穏やかなものであれ、無秩序が一瞬毎に変化しようとしている明確な印象を与えている。砂丘は形を変え、動物も姿勢を変えるところである……）

事実を描くとは、その平凡さを描くばかりでなく、事実の迷装を描くことでもある。

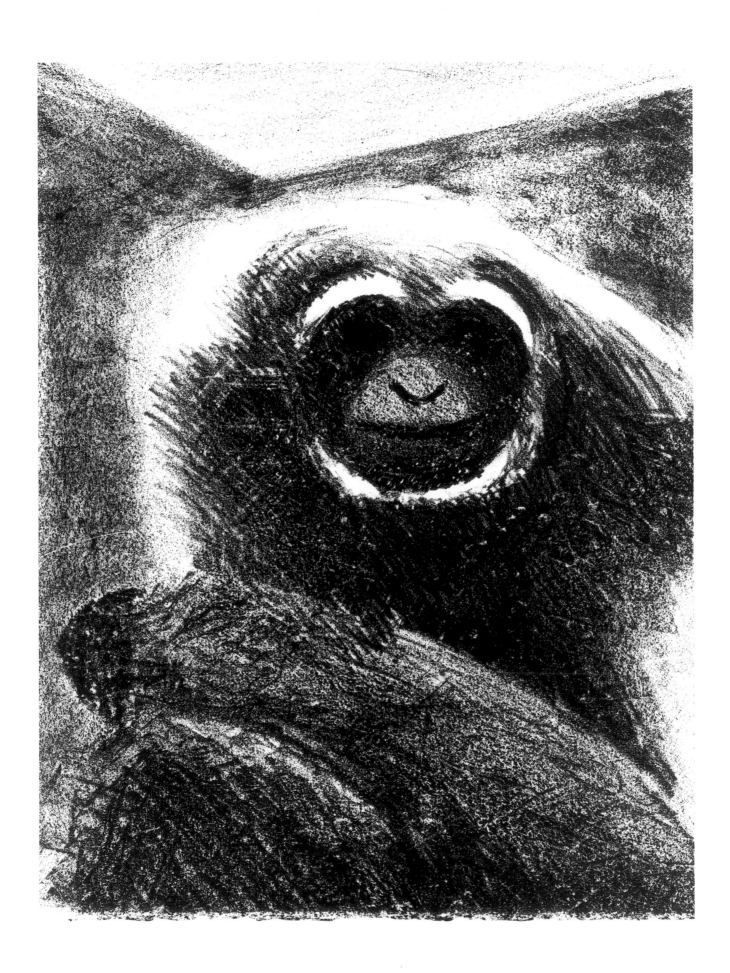

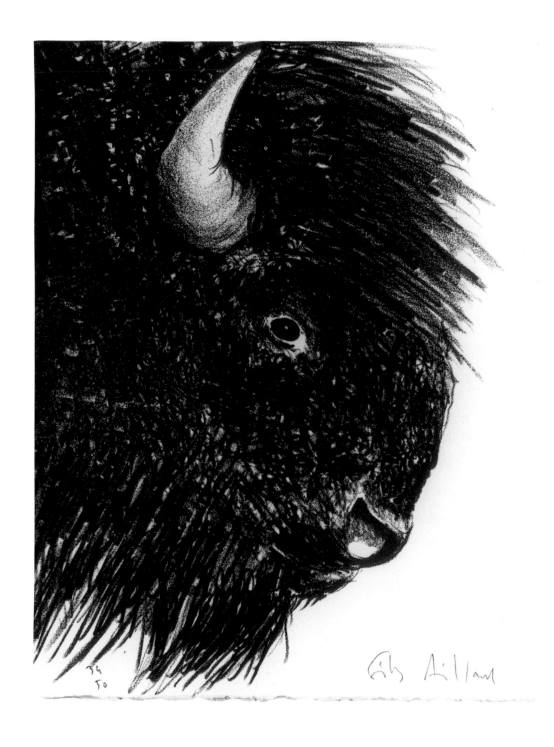

cause, as he himself says "One must paint things as they wish to be painted."

He does not therefore need to avail of a deeply personal style, however felicitous (like Léger, Mondrian or Warhol, to mention only the best) as a sort of earnest, visible in advance as it were, of the originality and quality of each new canvas. This is the sense in which his work, why not say so? forms part of the most eminent of

アイヨーの作品が、現実が画面となる瞬間に取る様相（言葉での表現や予測がいちばん難しい）をまったく回避していないのは、「ライオンをつくる」とか「海をつくる」といった月並みな方法を（この点ではボワロンと違って）取っていないからである。と言うのも彼自身が述べているように「モノが描いて欲しいと思うように描かねばならない」からである。

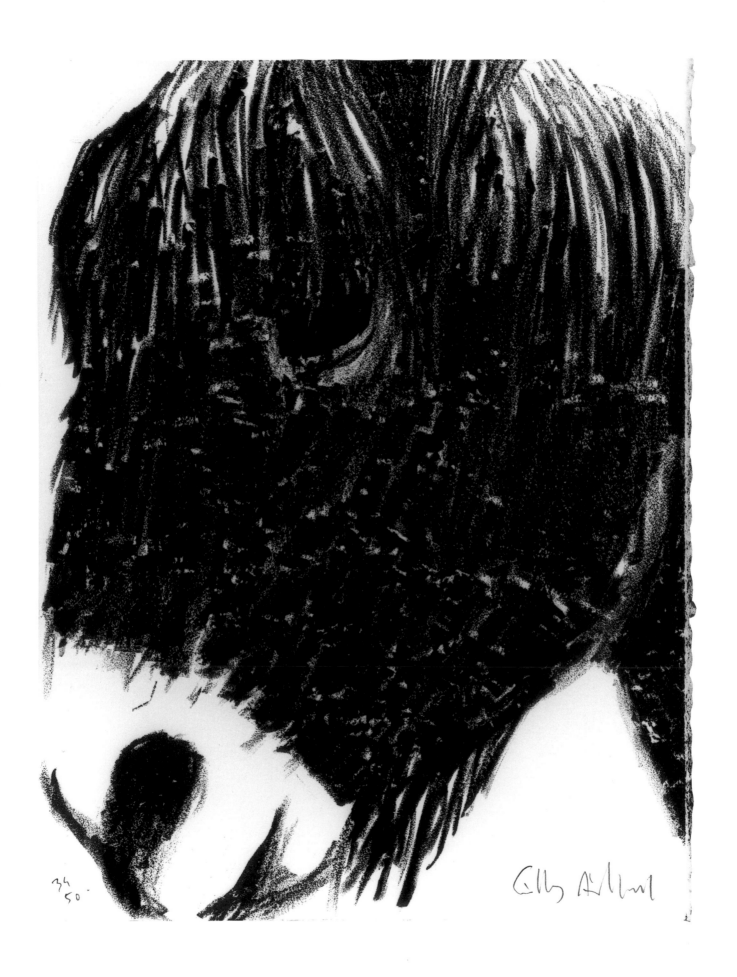

34/50

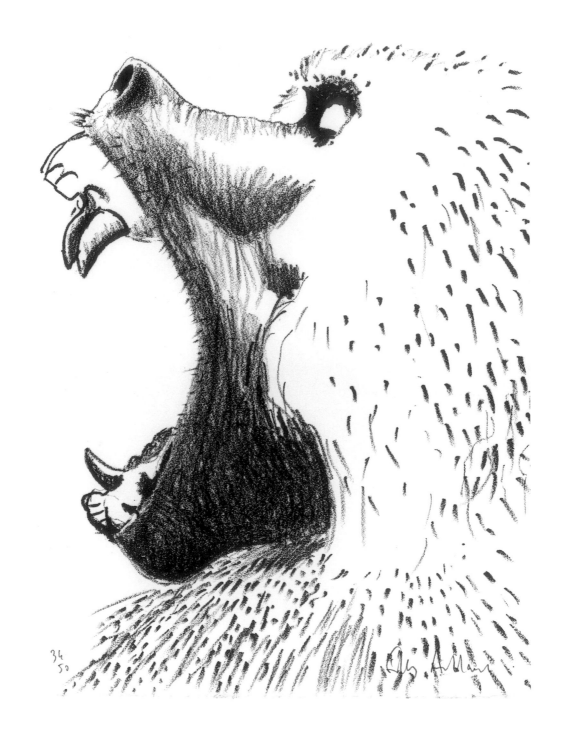

34
50

all pictorial traditions - that of Velasquez, of Vermeer, of Goya and of Manet - according to which the more invisible the style, the greater the artist.

If one were to skim through Aillaud's catalogs (that is to say photographs of his paintings), one might be inclined to complain about the photorealism of his painting.

Yet it does not at all belong to the schizophrenic

だからこそ、どんなに率直かつ視覚的に適切であるように見えても、アイヨーの場合はオリジナリティとクオリティを作品に求めるうえで特異なスタイル（最良の例を挙げればレジェ、モンドリアン、ウォーホルなど）に頼る必要はないのである。

ここに、スタイルが目につきにくいほどアーティストは偉大であるという観点からすれば絵画そのものの伝統──ベラスケスの、

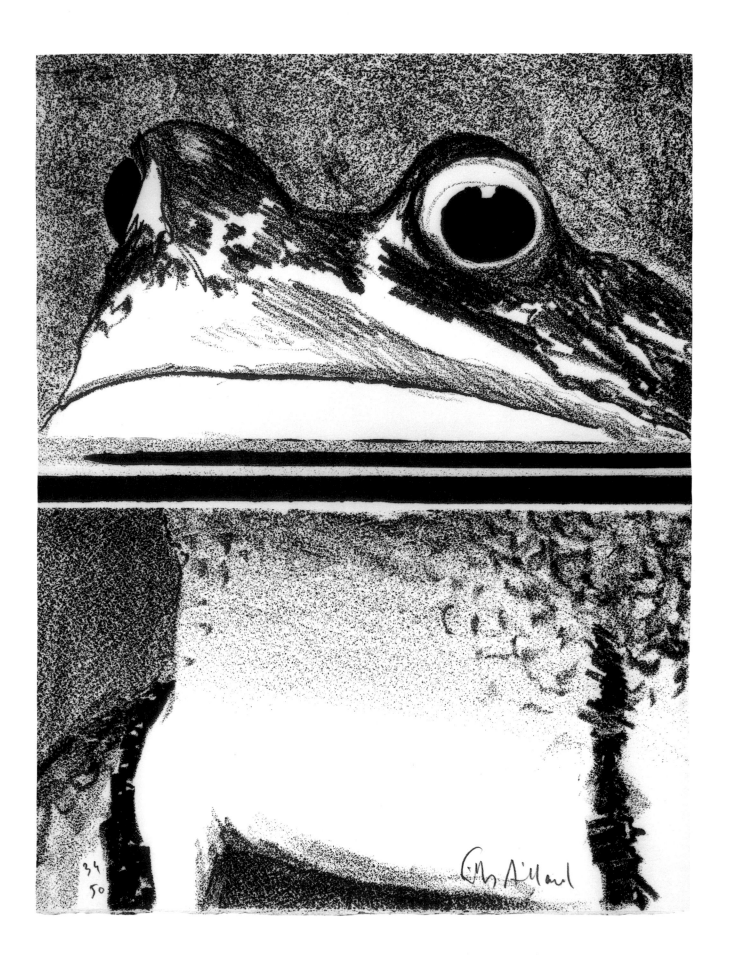

34
50

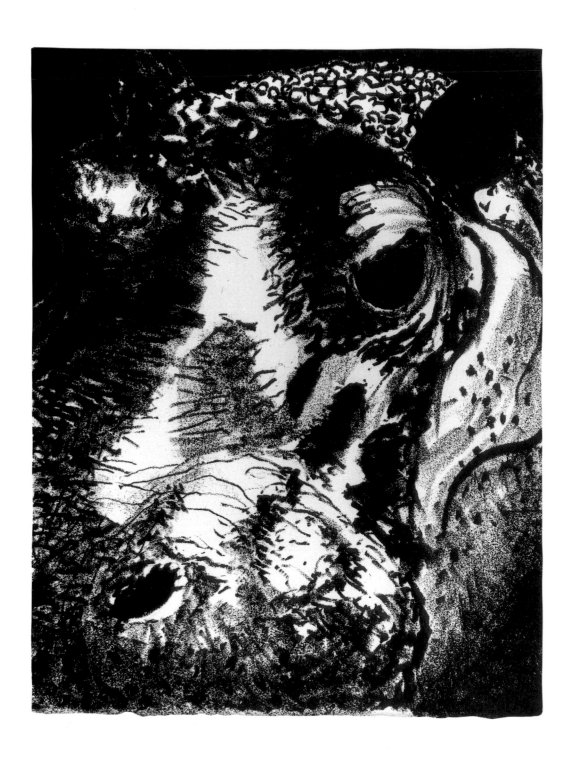

composition

passion of the hyperrealists for anecdotal door knobs to the hallucinated identification with each part of the whole that causes them to lose sight of the overall composition and irreversibly paralyses all of the objects that they may have wished to render.

(When you approach a hyperrealist sculpture that you find hallucinatory, as you stretch out your hand to stroke the skin, have you never felt death at your fingertips?).

フェルメールの、ゴヤの、そしてマネの——のうちで、きわめて優れた部分を彼の作品がなしているという（あえてそう言おう）意味があるのだ。

アイヨーのカタログ（すなわち彼の作品の写真だが）に目を通せば、その写真的リアリズムに不満を持つ人間も出てくるだろう。

しかしながらそれは、全体の構成を見失なったり、表現主題を

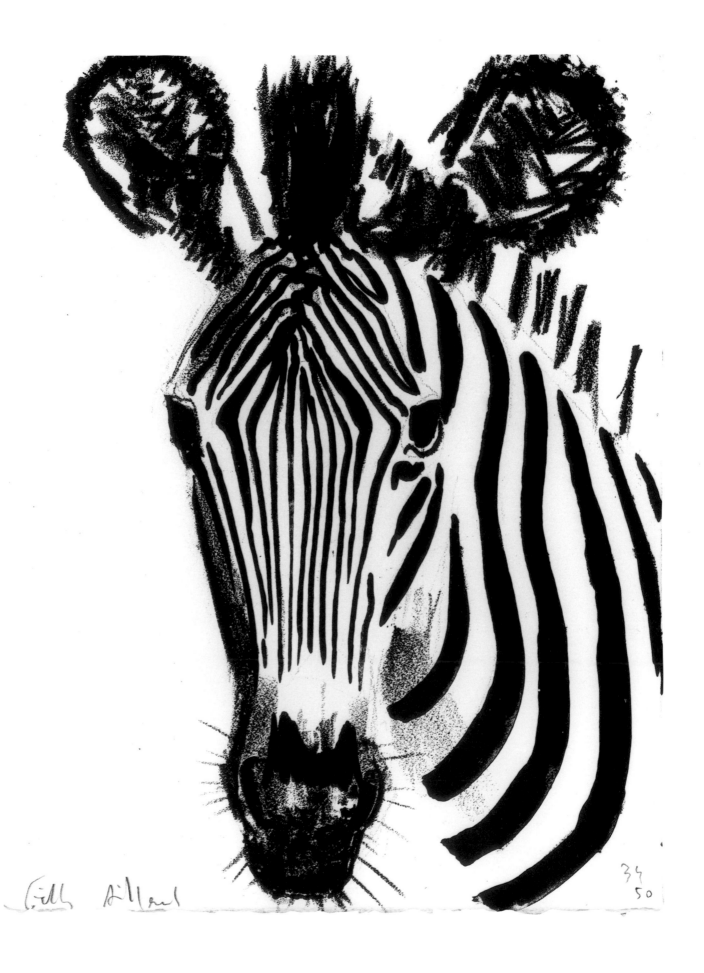

34
50

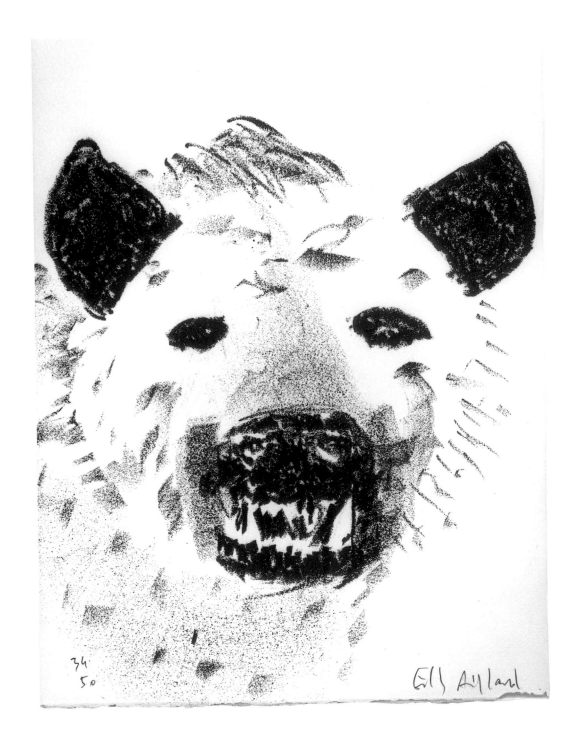

34
50

Gil5 Ayland

Unlike the works produced in the laboratories of hyperrealism, Aillaud's painting suggests such easy and rapid execution that it gives life to the invisible; to the soft wind, to time, to fragility, to sleep.....

There is nothing anecdotal about the wavelets made by the water on the sand in this painting.

These wavelets are not a faithful reproduction of those that exist in reality, they are a faithful account of

致命的に麻痺させてしまうような、全体の中での部分に対する目眩のするような確認作業、つまり逸話的処理への扉の取っ手を求めるハイパーリアリストの分裂症的情熱とはまったく異なったものである。

（幻覚を起こすようなハイパーリアリストの彫刻に近づいて肌に触れようと手を伸ばすとき、指の先に死を感じたことはないだ

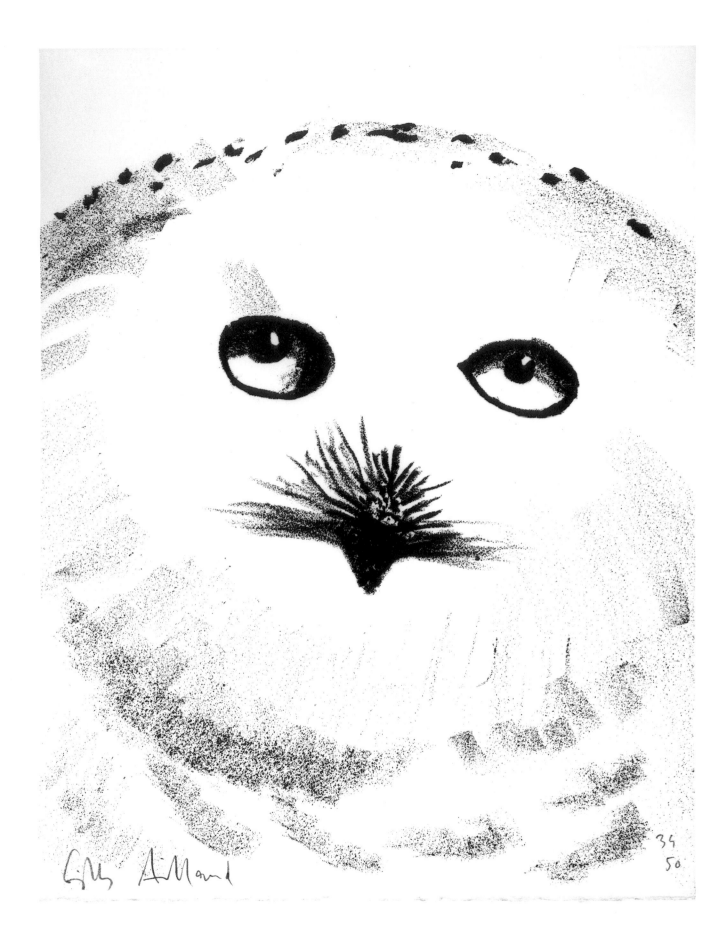

Gilly Aillaud

34
50

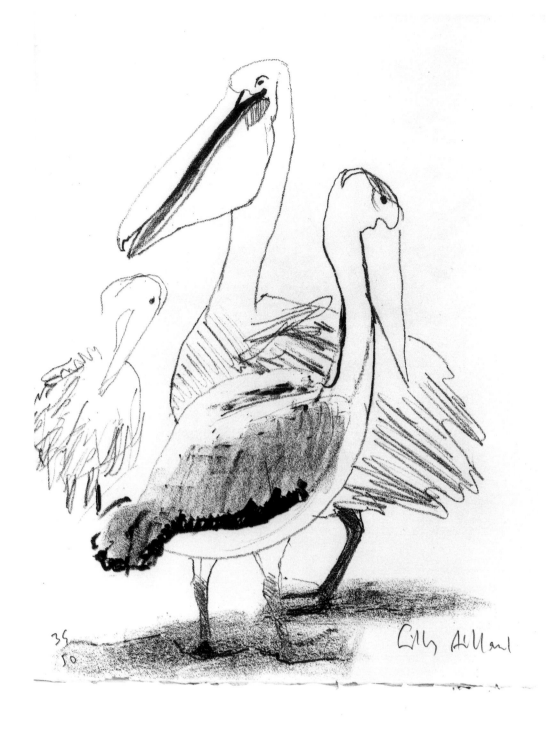

35/50

the event of low tide. Nobody would dream of checking the number of pieces of seaweed, of wavelets, of reflections, of fly specks or of the white tips of foam: no laborious preparation, no narcotic detail, no paralysis.

Gilles Aillaud paints close up what he sees from afar and the miracle is that his hyperrealism borders on the scribbled sketch.

ろうか)。ハイパーリアリズムの実験室で制作される作品とは違って、アイヨーの余裕を持った素早い作業は目に見えないものに生命を与えてくれる。柔かな風、時間、はかなさ、眠り……。

　この作品の、砂の上に水がつくるさざなみになんら逸話的なものはない。さざなみは現実に存在するものの忠実な再生ではなく、潮の満ち引きそのものの忠実な描写である。海草の枚数、さざな

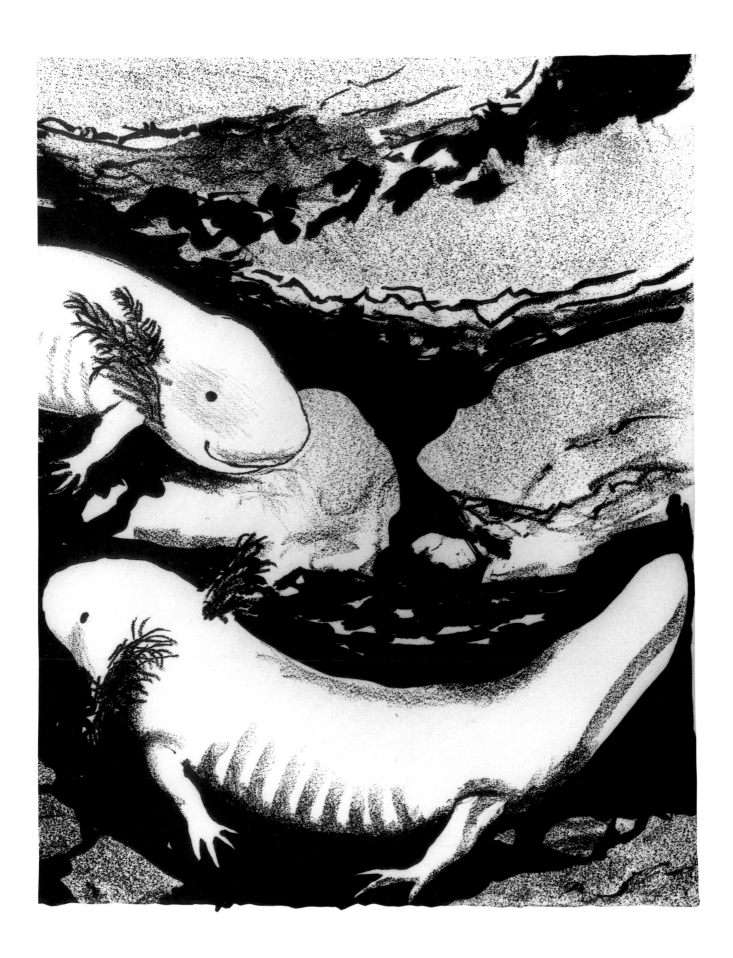

rapid execution that it gives life to the invisible; to the soft wind, to time, to fragility, to sleep.....

There is nothing anecdotal about the wavelets made by the water on the sand in this painting.

These wavelets are not a faithful reproduction of those that exist in reality, they are a faithful account of the event of low tide. Nobody would dream of checking the

みの数、光の反射、しみのようなハエ、あぶくの白い端、そんなものの数を数えようと思うだろうか。手の込んだ準備もなし、あくびをさそうディテールも硬直化も、なにもない。

ジル・アイヨーは遠くから眺めたクローズアップを描く。その、描きなぐりのスケッチがほとんどハイパーリアリズムだということが驚異なのだ。

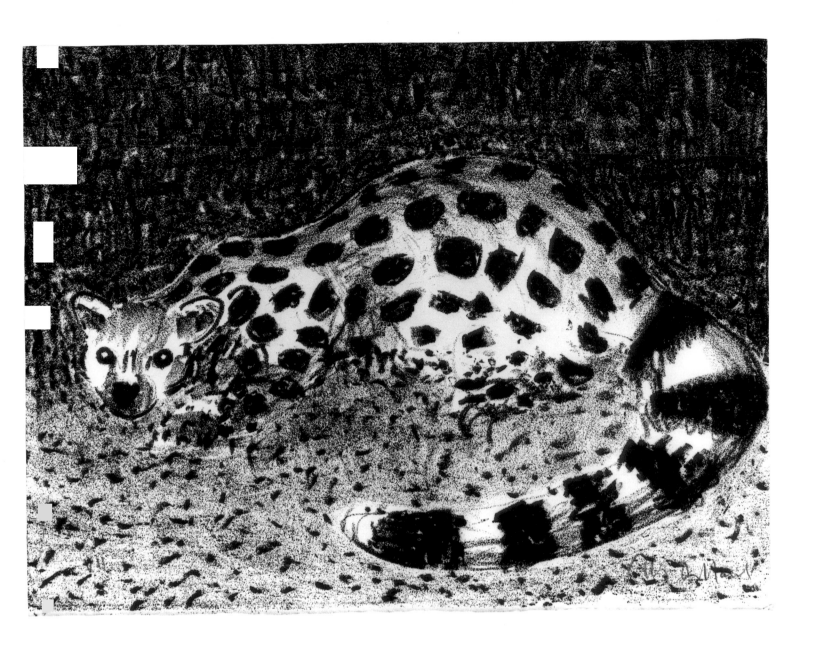

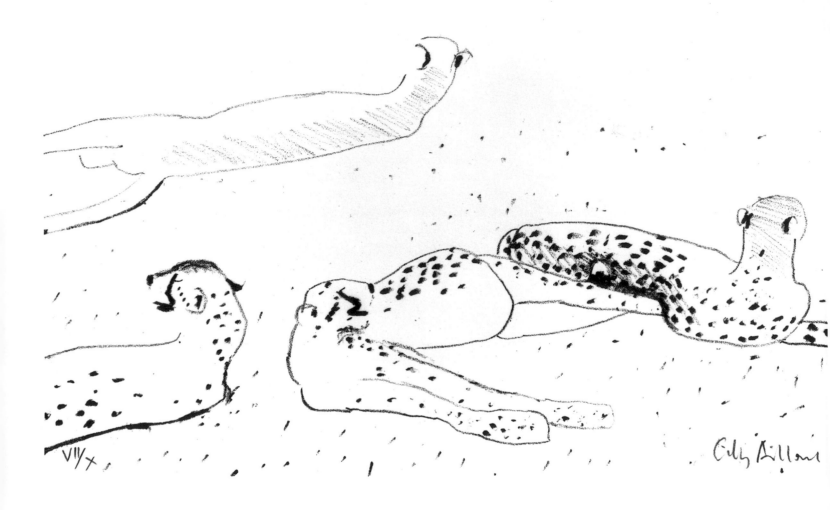

The stock-in-trade of lyrical and minimalist effects, the literary or avant-garde gesture, are foreign to Gilles Aillaud's painting, within which something powerfully neutral, sober and clear lies hidden - the nub of its brilliant mystery.

Here shadows fall blue on to the sand, the water is always still, walls are luminous, backgrounds white, skin is pink and, occasionally, stage make-up covers faces in

リリカルでしかもミニマリスト的効果という常套手段、文学的でアヴァンギャルドなジェスチュア、どちらも無縁なのがジル・アイヨーの作品であり、そこにはパワフルに中立的で冷静かつ明確ななにか、その見事な神秘の核心が隠されている。

ここでは砂の上に青い影が落ち、水は常におだやかで、壁は明るく輝き、背景は白く肌はピンクであり、時としては4色混合の舞

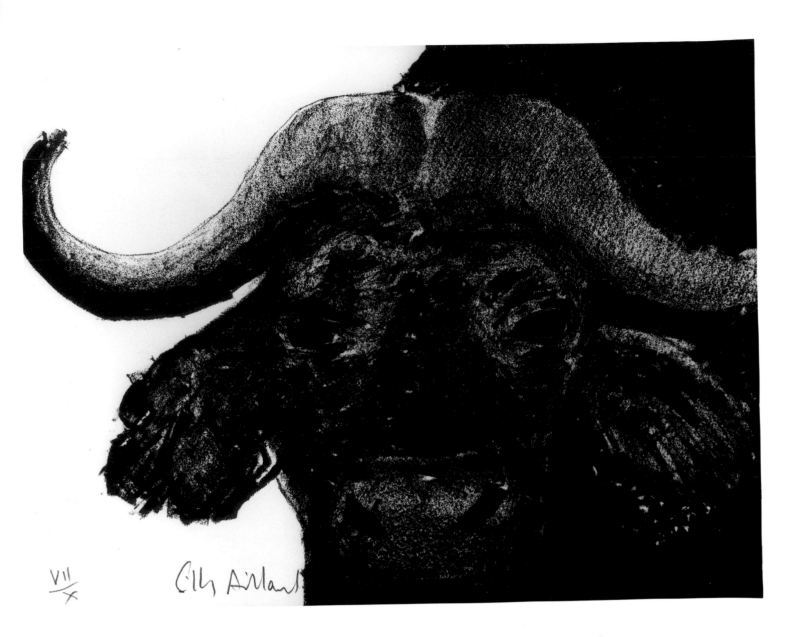

VII/X Giles Aillard

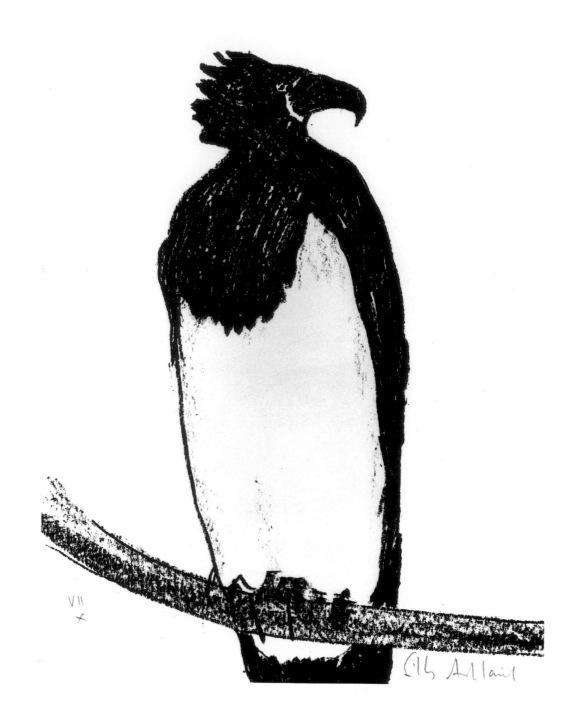

a motley of four colors.

　From the depths of bitter yellows, of joyous pinks, of whitewash and of blue-green, things and beings unflinchingly proffer their sunburnt appearances, and their mystery remains complete in a whiteness where shadows submerge.

　It is in virtue of this, I feel (in other words, with no recourse to the symbolism of light and darkness), but I

台メイクが顔をおおう。

　苦い黄色、悦ばしげなピンク、水性の白、青味がかった緑の深みからモノと生き物とが日に焼けた外観をしっかりと見せ、そして神秘は影が消えてゆく白のうちに全き姿のまま残る。

　だからこそ私は思う（言いかえれば光と影のシンボリズムに頼ることなしに）、アイヨーは、これ以上詳しく説明することはでき

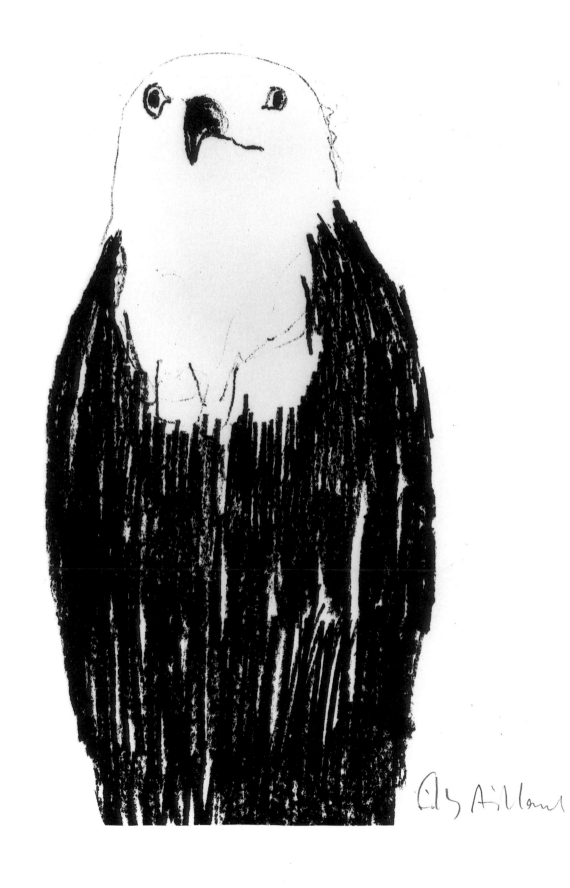

VII
X

Ely Aillaud

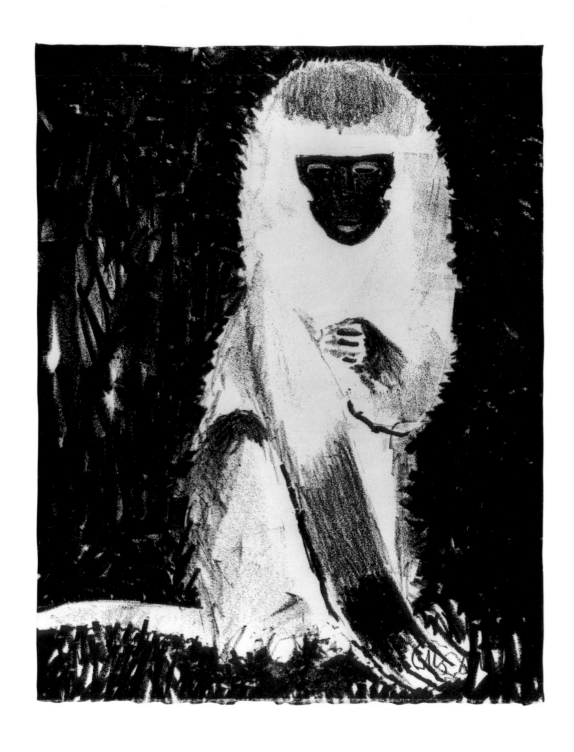

feel unable to explain in greater detail, that Aillaud is a modern painter.

ないが、現代の画家なのであると思う。

Hector Obalk
(translated by Michael Walsh)

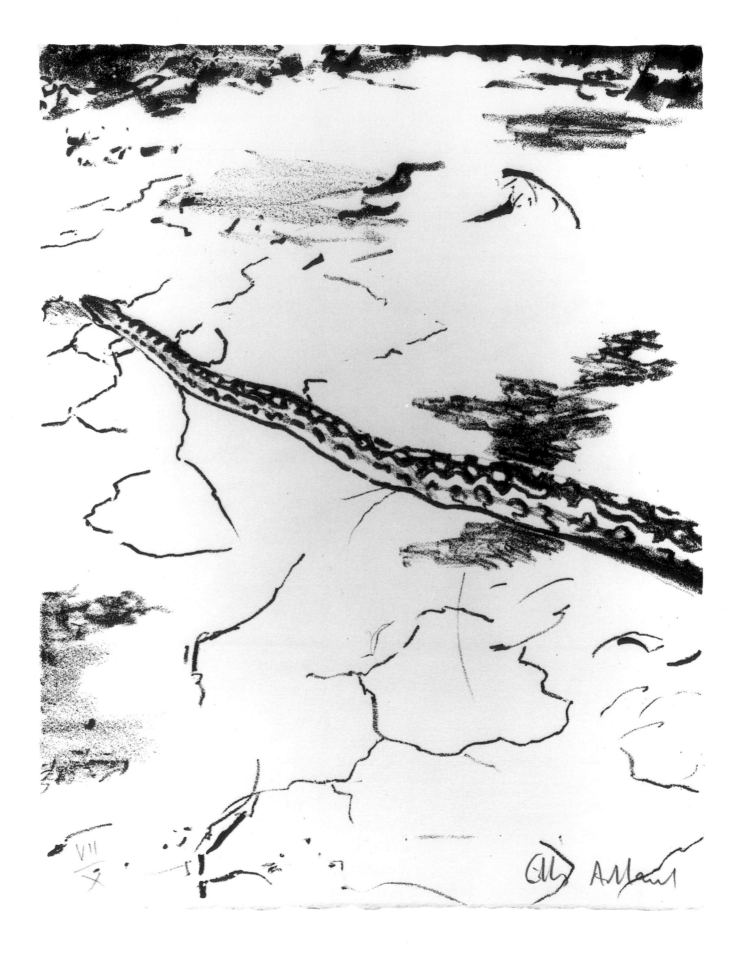

VII
X

list of the works

Complete lithographic work, 1978 -1989

5 *Tortue no.1,* 1978
 65 x 50 cm. lithograph, edition of 30, Atelier Bordas publisher.
6 *La paille,* 1980
 50 x 65 cm. lithograph, edition of 40, Atelier Bordas publisher.
7 *Crocos,* 1980
 50 x 65 cm. lithograph, edition of 40, Atelier Bordas publisher.
8 *Serpent,* 1980
 65 x 50 cm. lithograph, edition of 80,
 Les Amis du Musée d'Art Moderne de la Ville de Paris publisher.
9 *Rhino,* 1982
 63 x 90 cm. lithograph, edition of 40, Atelier Bordas publisher.
10 *Crocodile,* 1983
 70 x 100 cm. lithograph, edition of 30, Atelier Bordas publisher.
11 *Serval no.1,* 1984
 76 x 56 cm. lithograph, edition of 100,
 Maison de la Culture de Grenoble publisher.
12 *Les panthères,* 1984
 100 x 80 cm. lithograph, edition of 30, Atelier Bordas publisher.
13 *Serval no.2,* 1984
 65 x 50 cm. lithograph, edition of 200, Sageco publisher.
14 *Varan,* 1985
 50 x 65 cm. lithograph, edition of 30, Atelier Bordas publisher.
15 *Deux crocos,* 1985
 75 x 105 cm. lithograph, edition of 110, Lintas publisher.
16 *Les chevaux de Skiros,* 1985
 75 x 105 cm. lithograph, edition of 30, Atelier Bordas publisher.
17 *Les singes,* 1985
 160 x 120 cm. lithograph, edition of 15, Atelier Bordas publisher.
18 *Tortue no.2,* 1987
 75 x 100 cm. lithograph, edition of 15, Atelier Bordas publisher.
19 *Serval no.3,* 1987
 76 x 56 cm. lithograph, edition of 200, Sageco publisher.
20 *Masaï Mara,* 1989
 120 x 160 cm. lithograph, edition of 10, Atelier Bordas publisher.
21 *Amboseli,* 1989
 120 x 160 cm. lithograph, edition of 10, Atelier Bordas publisher.

Selection of oil paintings

23 *Lion endormi,* 1971
 300 x 200 cm. oil on canvas
 photo. J. Hyde courtesy Galerie de France, Paris
24 *Famille de lions,* 1969
 198 x 277 cm. oil on canvas
 photo. GCB/LOSI courtesy Galerie Claude Bernard, Paris
25 *Otaries,* 1973
 200 x 300 cm. oil on canvas
 photo. GCB/LOSI courtesy Galerie Claude Bernard, Paris
26 *Singerie,* 1973
 130 x 195 cm. oil on canvas
 photo. François Walch courtesy Galerie de France, Paris
27 *Ours,* 1988
 89 x 116 cm. oil on canvas
 photo. J. L'Hoir, Paris courtesy Galerie de France, Paris

selections of lithographs from
Encyclopédie de tous les Animaux y compris les Minéraux
[Encyclopedia of all Animals, including Minerals]

volume 1, 1988:
("box-book" of 52 lithographs, 32.5 x 25 cm. each,
edition of 50, Atelier Bordas publisher)
 Cover : Okapi
page 29 : Gibbon • 30 : Bison • 31 : Ane du Poitou • 32 : Hamadryas
 33 : Grenouille • 34 : Hippopotame • 35 : Zèbre • 36 : Hyène
 37 : Harfang • 38 : Pélican • 39 : Axolot

Volume 2, 1989:
("box-book" of 52 lithographs, 32.5 x 25 cm. each,
edition of 50, Atelier Bordas publisher)
page 41 : Genette • 42 : Guépard • 43 : Buffle • 44 : Aigle à poitrine noire
 45 : Aigle pêcheur • 46 : Vervet • 47 : Python